HAUNTED HISTORY OF
OLD SAN ANTONIO

LAUREN M. SWARTZ
AND JAMES A. SWARTZ

Haunted
America

Published by Haunted America

A Division of The History Press

Charleston, SC 29403

www.historypress.net

Images courtesy of the authors unless indicated otherwise.

First published 2011

Manufactured in the United States

ISBN 978.1.60949.979.2

Library of Congress CIP data applied for.

Dedicated to the Canary Islanders and their descendants.

CONTENTS

Acknowledgements 7
Introduction 9

One: The Menger Hotel 13
Two: Huebner-Onion House 27
Three: The Council House Fight of 1840 33
Four: Comanche Lookout Hill 37
Five: San Fernando Cathedral and Main Plaza 43
Six: Black Swan Inn 53
Seven: San Antonio Vice 57
Eight: The Emily Morgan Hotel 71
Nine: The Hotel Indigo 77
Ten: The Old Bexar County Jail 81

Bibliography 93
About the Authors 95

ACKNOWLEDGEMENTS

We know this book would not have been possible without the help of our family and friends who supported us through our endeavors.

To the friendly staff and ghosts of the Menger Hotel, we have loved working with you side by side these past few years. We would also like to thank Ernesto Malacara for sharing his great knowledge of the historical Menger Hotel.

Also, to the staff of all the museums, hotels and historic sights we visited during the process of writing this book, we thank you for sharing with us your stories and information.

Lastly, to the many guests on our tour groups over the years who have shared with us their stories and supported us along the way, this book would not be possible without you.

INTRODUCTION

Growing up in San Antonio, I was constantly taught by my family the history of our beautiful city. The main reason for this was because my family and I are descendants of the original people of San Antonio known as the Canary Islanders. They were chosen by the King of Spain in the early 1730s to make the long journey from their homes to establish a new world. I often wonder what they must have thought when they first came to this area. They had many hardships and struggles with the land and constant battles with Indians. Eventually, they settled into their new lives and began to build the city we know today.

Almost three hundred years later, my family still lives here and continues to teach their children about their rich heritage. Because of their teachings, I grew up knowing a lot about San Antonio and its history. When I had friends visit me, I couldn't help but give them my own tour of the city. I felt like I had a great knowledge of the city and wanted to share as much as I could about it. I not only loved the history but was also fascinated by all the ghost stories San Antonio is home to.

During Halloween, it was a family tradition to read from a ghost book while we drove around at night and visited each spot. I loved

to hear my mother recount all the spooky tales. Halloween was always my favorite time of year, and I loved to host parties and invite friends over. Somehow, I always ended up near the campfire telling ghost stories.

When my family went on vacation, we tried to visit historic cities so that we could learn more about them. At night, we would take a ghost tour. (I was always absolutely enamored and thrilled by these tours).

Later on in life, I met my future husband, James, who was living at that time in Jacksonville, Florida. He lived about thirty minutes from St. Augustine, known as the oldest operating city in the United States. It is also considered to be extremely haunted. As luck would have it, one of our very first dates was on a ghost tour. James was very skeptical at first; he didn't know what to expect. After the tour ended, he was surprised by how much he enjoyed it, and all the history he learned.

After we were married a year, we decided to go on a ghost tour in San Antonio. Living here all these years, I had never thought of doing one in my own city. I was curious how they would present our history and ghost stories. After trying out a few different tours, we became somewhat disappointed. We didn't feel we had taken anything away from our experience like we had with the other tours. They also seemed to focus too much on ghost hunting rather than the history and the reasons ghosts haunted certain buildings.

This is around the time that we decided to open up our own ghost tour company. This was a dream come true for me, as I had the opportunity to dress up in historical costume and talk about the history and ghost stories of my favorite city. We were thrilled by how fast the company grew, and soon, we added on a second tour with the Menger Hotel.

After doing so many tours, we got to know a lot of the employees that worked in haunted buildings and also the owners. They all told us their own experiences and why they knew their buildings were haunted. We began to compile their eyewitness accounts and decided that we wanted to write a book. San Antonio just has too much history and too many ghost stories to tell about in one evening. A book would

give a reader the opportunity to learn and explore even more of the city's haunted past.

This book is intended to give people a better idea of how our city once was and the reason why there are so many ghosts that haunt it. We hope the reader comes away from reading this book with more knowledge of this beautiful city and all the many spectral tales that come with it.

CHAPTER ONE

THE MENGER HOTEL

There are very few hotels that exist in the United States today that can boast of as rich a history and as spooky of ghost stories as the Menger Hotel can. Set apart from almost any other hotel in the country, the Menger Hotel will certainly live in America's history as one of the most influential hotels.

Built in 1859 by a German immigrant named William A. Menger, this hotel has quite a story to tell. William Menger was a popular man in San Antonio because he was known for brewing the finest tasting beer in the city. His beer was so popular and sought after that he decided to open up San Antonio's first brewery called "the Western Brewery," located on Alamo Plaza right next door to the famous Alamo. On the other side of his brewery, he also operated a boardinghouse with his wife, Mary.

Mary was a widow who operated the boardinghouse by herself when she first met Menger. William had come to San Antonio looking for work and stayed at the boardinghouse for three years before they both decided to marry. Years later, they had two thriving businesses right next to each other and a demand for more rooms and space at the boardinghouse. They decided that they were going to turn the boardinghouse into a luxury hotel and call it the Menger Hotel.

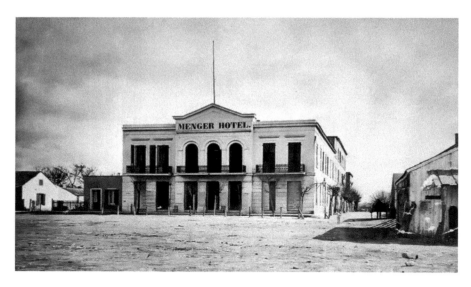

Original photo taken of the Menger Hotel when it was first constructed. *Courtesy of the Menger Hotel.*

They hired local architect John M. Fries, who designed the two-story, stone-cut building with classical detail. Foundations were laid June 18, 1858, and work was completed by January 1859. On February 1, they opened the Menger Hotel with a lavish gala that allowed reporters and the wealthy to feast their eyes on the luxurious hotel. News traveled fast as reporters boasted of its finery and dubbed it "the Finest Hotel West of the Mississippi."

Within three months, the Mengers had enough business that they started to plan on expanding the hotel, which was originally built with only fifty rooms. This time, they added on forty more rooms—making the Menger, with a total of ninety rooms, the largest hotel in the area.

The hotel's nationwide fame, good service and excellent cuisine made it a popular place for many influential and famous people to stay. These people included William Sydney Porter, who mentioned the Menger in several of his stories; General Robert E. Lee; Ulysses S. Grant, who spent four days in the hotel; Sidney Lanier, who

A current photo of the original lobby of the Menger Hotel.

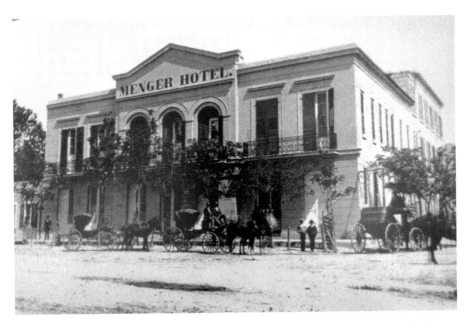

An exterior photo of the Menger Hotel, circa 1865. *Courtesy of the Menger Hotel.*

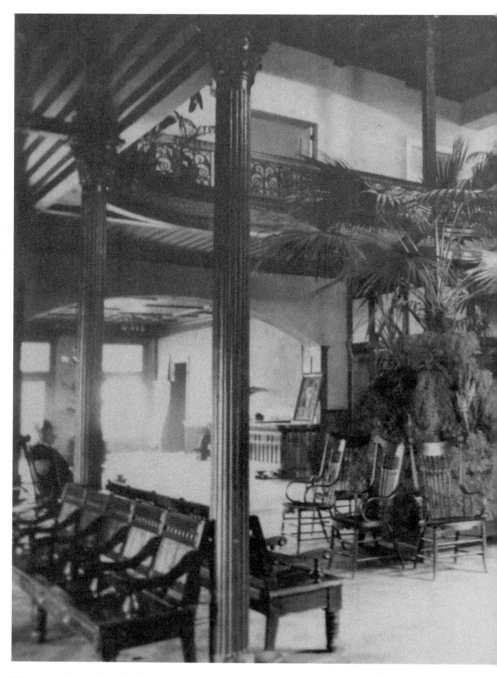

Photo of the original lobby inside the Menger Hotel. *Courtesy of the Menger Hotel.*

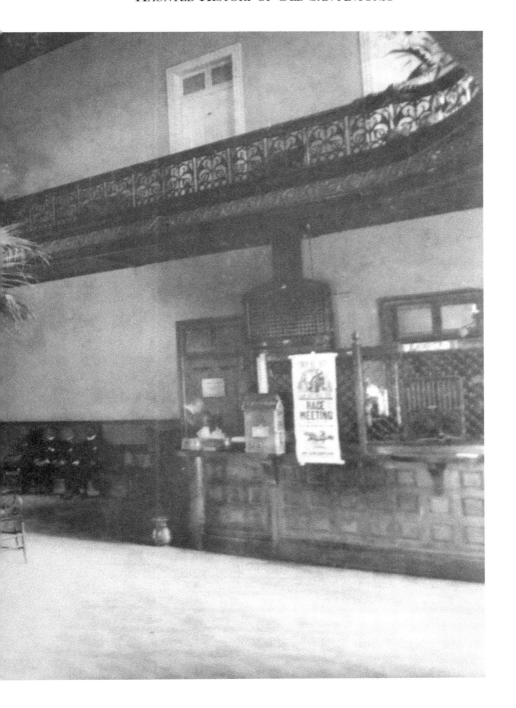

wrote "San Antonio de Béjar" while he stayed at the Menger; and Teddy Roosevelt, who visited three different times.

During one of those visits, Teddy recruited his famous Rough Riders from the Menger Hotel bar [NOTE: as in captions] in 1898. They claim that he actually rode into the famous bar on his horse to recruit his men. The original table where he enlisted the Rough Riders is still inside the Menger Hotel to this day, on the third floor. These men went on to battle in the Spanish American War.

Years passed, and the Great Depression came, slowing down business significantly. People no longer had money to travel and stay in expensive hotels. However, in the 1940s, business began to pick up, and new renovations were added to the building. Famous faces began once again to flock to the hotel. These people included Mae West, Babe Ruth and Roy Rogers. At one point, it is said that as soon as people arrived off the train, they rushed over to the Menger Hotel in order to secure a room in such luxury.

The Colonial Room Restaurant also experienced high demand and popularity. It was known throughout the city as having the best and most decadent food in the area. Some of its most popular items on the menu included such specialties as wild game, mango ice cream and snapper soup, made from turtles caught in the San Antonio River.

Today, the Menger Hotel still exists as a central landmark in the city of San Antonio and is now on the National Registry of Historic Places. Its history, beautiful architecture, famous food and location draw many visitors to it daily. But perhaps the most interesting part of this hotel is its many hauntings.

The Menger has had so many different types of tragedies on the premises—including a battle that took place next door—and people stay throughout the years that it's no wonder the hotel bears the title of "Most Haunted Hotel in Texas."

When the Menger was first built, there were not a lot of other buildings in the area. Nor were there many hospitals. If someone took sick or was about to give birth, he or she would often take a room at the Menger and have the doctor visit him or her there. Because of the lack of clean living areas and no hospitals, the hotel

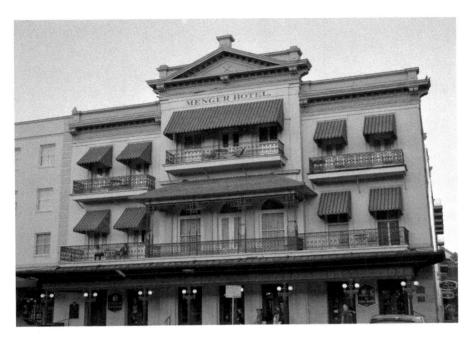

A current photo of the exterior of the Menger Hotel today.

was the best place to go. Many people did lose their lives to some sort of ailment or terrible childbirth inside this building.

Let's not forget also that the Menger sits next door to the Alamo and was only built a short twenty-three years after its fall. Many men lost their lives where the building sits today, and some claim to see the spirits of those very same men walking the halls of the hotel.

There are a total of thirty-two known spirits that haunt the Menger Hotel, and each one of them seems to have its own story. But of the thirty-two, there are three that stand apart from the rest. Their stories follow.

TEDDY ROOSEVELT

Teddy, as we know, recruited his Rough Riders from the Menger's bar in 1898. He must have loved the hotel and its bar because he

The Menger Hotel bar where Teddy Roosevelt recruited his Rough Riders in 1898.

frequented them so often. Today, when the staff at the bar closes up at night, they have seen a man appear at the bar watching them. Sometimes, he beckons or calls out to them, as if he wants to have a friendly chat with them. When they do get the opportunity to

speak to him, they claim he often tries to recruit them to join his Rough Riders.

A new employee had a very frightening experience at the bar one evening. It was his first time closing up the bar by himself, and as he was finishing, he heard something behind him. He turned and saw a man appear at the bar, watching him intently. Frightened, he ran past him to the doors but realized that they had locked on him. He banged on them, trying to get someone's attention. Eventually, someone heard the noise and unlocked the door for him. The poor employee was in a state of shock and could hardly speak. When he did eventually recount his tale, it was too late, for the man at the bar had long since disappeared.

SALLIE WHITE

The most often sighted ghost of the Menger Hotel is a young woman named Sallie White. Sallie was once a chambermaid at the hotel and was a wonderful employee on its staff. She loved her job and always completed her daily duties with the utmost care. Unfortunately, Sallie had a common law husband who was a very angry man. He lost his temper often, and he would take it out on Sallie when she arrived home (their house was located two streets behind the hotel). One day after an explosive argument, Sallie took off running down the street. Her husband pulled out his gun and shot her in the back three times. It took poor Sallie two days to die from her wounds, and because she was such a beloved employee to the hotel, the Menger brought her back and paid for her funeral costs of thirty-two dollars. That receipt is on display inside the hotel to this day and states the following:

> *Hotel Exp. Acct.,*
> *to cash paid for coffin for Sallie White, col'd chambermaid, deceased,*
> *murdered by her husband, shot March 28th died March 30th.*
> <div align="right">

For grave, $25.00
$7.00
$32.00
</div>

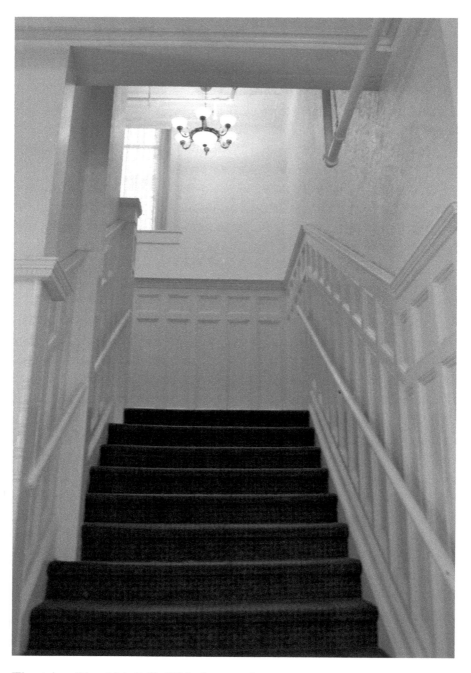

The stairwell in which Sallie White is most often seen.

Sallie, they say, has not given up on her daily duties. She is most often sighted walking up and down the different hallways, continuing on with the work she so greatly loved. She can be seen with an armful of towels or sheets, entering the different rooms. Many people have had experiences of seeing Sallie White over the years inside the hotel. One woman retold a story about an experience she thought she had with Sallie White. As she was sitting at the edge of her bed, flipping through the channels on her TV, she suddenly saw something walk through her front door. It was a woman dressed in a maid's uniform and carrying a towel in her arms that walked through the door and disappeared into her restroom. Another woman also had a similar Sallie White experience. She said as she got out of the shower and walked into her room, she found a woman folding sheets at the edge of her bed, and she could see right through her. Terrified, she ran down to the front desk and told the concierge what had occurred.

So if by chance you stay at the Menger Hotel and see a woman in old chambermaid attire, don't be alarmed; it's just young Sallie White carrying on with what she knows best.

CAPTAIN RICHARD KING

Richard started off his life as an indentured servant to a jeweler in New York City. His poor Irish family was so destitute that they had no other option than to sell him as a servant. Hating his indentured time with the jeweler, he ran away and hopped onto a ferry heading toward the Mississippi. Over the years, he established himself as a hardworking man who was also a great entrepreneur. He later on established his own steamboat company and was a blockade runner during the Civil War. During a visit to Corpus Christi in South Texas, he bought a large site of acreage that started his fabled King Ranch. Years later, the ranch grew into nearly one million acres, and King became a famous and very wealthy cattle baron.

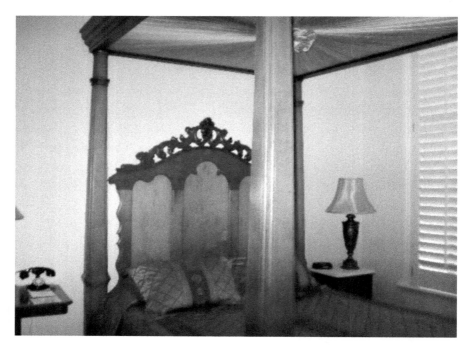

Captain Richard King's original bed, where he died in 1885.

King frequented the Menger Hotel on business trips when he came to San Antonio. He stayed there so often that he soon had his own private suite on the second floor. Later on in life, he developed stomach cancer and died inside his suite at the Menger Hotel on April 14, 1885. His funeral service was held inside the lobby, and thousands of people from all over came to pay their respects to this marvelous man.

Captain King, even after death, still seems to want his presence to be known. His spirit has been seen by hotel employees, guests and tour groups throughout the years. His original room is still located on the second floor and has been called "the King Ranch Suite." There are some pieces of furniture inside the room that are original to when Captain King lived there. One such piece is King's bed, located toward the back of the room. This is the exact bed where King died, and brave guests today have the opportunity to sleep here.

Some who have chosen to do so have claimed to see King or have had strange occurrences take place. One woman spent the night inside the famous suite and awoke to feeling a strange presence around her. When she opened her eyes, she claimed that she saw Captain King staring down at her as she slept in his bed. Another woman staying by herself heard footsteps in the living room and heard the shutters opening and closing. There is a curious red orb that has appeared in and around King's suite, near the chair outside the room and on his bed. That red orb appears nowhere else in the hotel except those areas.

Employees have also claimed to see King walking through the hallways and disappearing through his doorway. He sometimes makes his rounds on the second floor but almost always disappears when he comes to his suite. The King Ranch Suite is considered to be one of the most active parts of the hotel. If you are brave enough, I suggest you try a night inside this famous room.

OTHER SPIRITS

There are, of course, many other spirits that haunt this hotel. Perhaps they are not as famous as the previous three, but they have still made their presences known.

The Menger is located next door to the Alamo, and the spirits of some of the men who died there can be seen inside the hotel. Small children have seen soldiers standing over the railing on the second floor, looking down below. Others have also been seen in the new lobby walking about or standing near the doors.

A Spanish conquistador has also made an appearance in the lobby. He stands in full armor, as if he is preparing for something.

In the courtyard, the Chisholm Trail marker stands to commemorate the history of cattle drives and Texas ranchers. Many of these men frequented the hotel at that time and have been known to visit to this day. Their ghosts have been seen in different rooms and the bar area.

In the late 1800s, a small girl was tragically run over by a horse and carriage outside the Menger. After this, her small spirit has been seen in the lobby behind the front desk, at the Colonial Room Restaurant and in the bar. She is a mischievous spirit that likes to play games with the staff. George and Sigrid of the Colonial Room Restaurant have had their own experiences with the little girl they have nicknamed "Sarah."

On occasions when they have been alone cleaning up the restaurant at night, they have heard their names called out. When they turn to answer, there is no one in sight. Sigrid said that on one occasion, this young spirit came up behind her and grabbed her sides. Startled, she turned around, but there was no one in sight.

The front desk also has a lot of Sarah activity. Sometimes, papers and brochures fly off the shelf and a little girl's voice can be heard in the background. A recent photo taken by one of the staff showed a little girl in a white dress with long brown hair peering at the employees as they worked from around the corner. Sarah has also appeared on the upper level of the bar from time to time.

The history and ghost stories of the Menger Hotel are truly what make it such a fascinating and enamoring place to visit and stay. Its romantic architecture, great food and spooky aura continue to draw tourist and locals every year. Its title of "Most Haunted Hotel in Texas" will be left up for you to decide. If by chance you visit, perhaps you might see one of the famous ghosts of the very haunted and historic Menger Hotel.

CHAPTER TWO

HUEBNER-ONION HOUSE

On the outskirts of the city of San Antonio, inside Leon Valley, stands a little piece of history called the Huebner-Onion House.

In 1858, a young Austrian jeweler by the name of Joseph Huebner and his family bought two hundred acres in the area of Leon Valley. He built a one-story limestone house that became Leon Valley's first sustainable home. Some years later, Mr. Huebner decided to make his homestead into the only stagecoach stop from Bandera to San Antonio. In those days, the area was considered highly dangerous for travelers and stagecoaches because of steep terrain and muddy hills. The ever-present threat of Indian raids also made traveling difficult. The house and stagecoach inn had many Indian raids, and there remain today bullet holes and arrowheads inside the walls of the Huebner-Onion House.

In 1882, Joseph Huebner died of, some say, a very bizarre accident. He mistook a bottle of kerosene for a bottle of whiskey and accidently poisoned himself. This was also the year he had added a second floor to his beloved house.

Years later in 1930, a young family called the Onions move into the area. Judge John Onion Sr. loved the character of the old

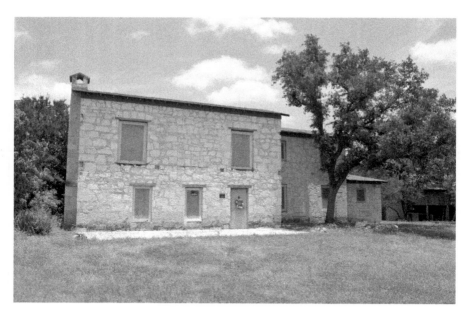

Current photo of the Huebner-Onion House.

Huebner House and decided to move his family into it. Not long after their move, they began to hear strange noises all throughout the day and night.

John Onion Jr. described in his own words some strange occurrences that had happened to him:

> *You would hear a click, like somebody had stepped on the bottom step of the staircase or stairwell. And then it would automatically come up. It wouldn't be a click here and then a click over here, a click by—it was kind of like somebody was trying to slip up the stairs, you know. And many a time I—when I was sick in bed— had my eyes glued on the door to see who might walk in. And I never told anybody because I didn't want anybody [to] think I was superstitious or heard ghosts or anything. Then, I found out that a good many of the other members of the family had had the same experience.*

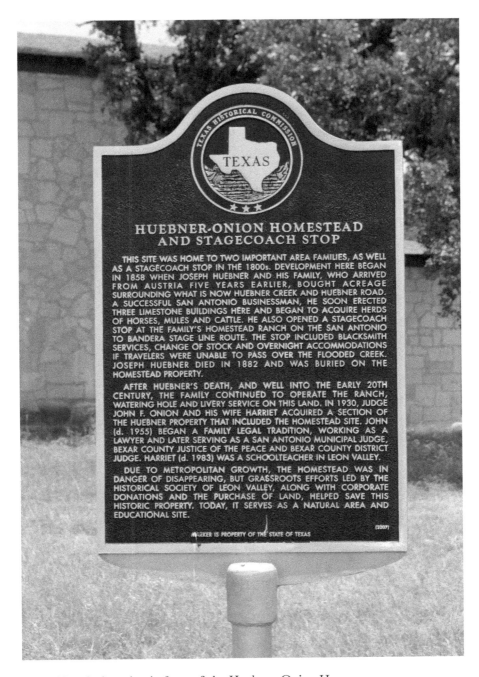

Texas historical marker in front of the Huebner-Onion House.

He also went on to describe a strange experience with a household item:

> *And I remember my mother had an iron that was a iron you sat down at. It wasn't a hand iron; it was a big machine iron that you could roll something. And then you had a little click on the side—you pushed your leg against it—and the iron would come down, and you'd roll this big roller under the iron and iron something. You push the click, and the iron would rise up, and then you could readjust it. Well, it made such a distinctive noise.*
>
> *And I always remembered one morning—I guess I was thirteen or fourteen—my dad was going to work. And when he left, car tires on the gravel woke me up, and we were sleeping out on the upstairs porch because we didn't have air-conditioning in those days; [it] was much cooler. And that machine was in one of the inner bedrooms, and I heard it running. And I heard the click. Heard the iron come down; I heard the click. And I thought, well, my mother was ironing something. So I lay there, and my brother was in a different bed; he was sound asleep. And so finally I got up, went into my bedroom off the porch, dressed; and went down to the kitchen. And when I opened the door to the kitchen, my mother turned around and said, "What were you ironing upstairs?" I said, "I wasn't ironing. You were." She said, "No, I've been down here in the kitchen since your—before your dad left even." It was so vivid to both of us at different locations. We both went together back up to where the iron was, and it was just as cold as it could be. My brother was still asleep on the porch. So I said, "I'll never explain that one."*

In the 1950s, Judge John Onion Sr. passed away, leaving his wife, Harriet, all alone. In 1983, she was the last of the Onion family to die inside the home. The Onion family soon vacated the house and never returned.

The home was abandoned for quite some time and soon became a popular site for local thrill seekers to hop the fence and visit. Some have different accounts of being inside the house and hearing the

sounds of glass or plates shattering, but when they checked, nothing was there. Others have reported hearing footsteps upstairs in the abandoned house and the soft music of a piano playing nearby. Some young thrill seekers have even heard the sounds of horses' feet and wheels against gravel, coming up the driveway toward the building. It sounds eerily similar to what a stagecoach might have sounded like. This noise has scared many trespassers away from the house. Perhaps some spirits are still visiting the inn by stagecoach.

Sadly, a local group of gang members recently broke into the house and spray painted and vandalized everything. The local historical society was raising money to help rebuild and establish the house as a museum when the vandalism occurred. Due to the sad occurrence, the society suffered a huge set back. Today, it still has plans to restore the house to its original form and make it a living-history farm.

The Huebner-Onion House will always stand as a monument to its town as a piece of history and eerie ghost stories.

THE COUNCIL HOUSE
FIGHT OF 1840

In the mid-1800s, the city of San Antonio was considered a somewhat dangerous city to live in. Scattered across its landscape were numerous bars, brothels, daily gun fights and, of course, many Indian battles. The most terrifying and hostile of all the tribes at that time were the Comanche Indians. In those days, it was said that if you were to venture out a mile past the city of San Antonio, your chances of coming back alive were less than 10 percent.

The Texans spent years fighting the Comanches and having to deal with the capture and abduction of many of their women and children. Abductions of children were especially numerous. Parents often had to teach their children what to do in case they were captured. My great-great-grandmother Lucinda Tarin was one of these children. When she was just twelve years old, she was captured and taken away by the Comanches. When her parents found that she was gone, they instantly knew what had happened. They assembled a search party and took off to find her. Luckily, they didn't go very far before they found their first clue. Remembering what her parents had taught her, Lucinda had torn pieces of her shawl and made a trail for her family to find her. When the Comanches saw the search party following behind

Location of the Council House Fight of 1840.

them, they panicked and abandoned Lucinda. She fortunately was not harmed and was taken back home safely. Unlike Lucinda, others did not fare so well, and many captives never saw their families again.

In March 1840, after two years of bloody battles and constant fighting, the Comanches decided that they wanted to negotiate a peace treaty. The Texans only agreed to have this meeting if the Comanches would bring back all of their women and children held captive. The Comanches agreed, and on the day of council, the Comanche chief leaders, their wives and children all came into the city dressed in their finest attire with their faces painted. They met at a one-story stone building called the Council House on the corner of Main Plaza and Market Street.

The Comanches brought with them one white captive and several Mexican children. The white captive was a young girl of sixteen named Matilda Lockhart. She had been held prisoner for over a year and a half. When the Texans saw poor Matilda, they were outraged. She had suffered several burns over her body, including her face. Her nose had

been completely burned off, disfiguring her face and rendering the child almost unrecognizable. Matilda told the Texans she had been severely beaten and raped by the men. She also told them there were over a dozen abducted women left back at the camp. This angered the Texans because they believed that the Comanches had broken their truce. Words were exchanged, and within moments, the situation turned ugly. The Texas militia fired on the chief leaders and their families point blank, killing many of them. Some of the Comanche women and children waiting outside began firing their arrows after hearing the commotion inside. In the end, thirty-five Comanches were killed: thirty men, three women and two small children. Seven Texans died as well.

After the battle, the Texans spared one Comanche squaw to go back to her camp and tell the others what had taken place at the council house. The Texans wanted to send the Comanches a warning to bring back the remaining captive women. When the squaw returned to her camp and told how their husbands, fathers and children had been killed, it enraged the Comanches. They grabbed the remaining prisoners and burnt them alive.

Still to this day, The Council House Fight of 1840 is considered the second-bloodiest battle to take place in San Antonio's history. The incident ended the chance for peace and led to years of hostility and war.

Today, the Council House still sits within view of the San Fernando Cathedral on Main Plaza. It has been bought and sold over the years and was most recently a Catholic bookstore. Now it sits dormant with a "For Sale" sign on it. Many people who pass by this building do not even realize the sad event that once unfolded here.

Visitors and residents of the downtown area often walk through this plaza at night and have reported seeing and hearing weird phenomena around the Council House. Gunfire and screams can sometimes be heard coming from inside the house. Other people have reported hearing a shrill Comanche war cry from the same area. At times, you can even hear the soft chanting of Indian war calls. Several photos have been taken of the area, and there are usually a lot of

orbs in its vicinity. One photo even displayed what appeared to be a Comanche woman inside one of the windows. When this building was in operation as a bookstore, it was reported that books would fly off the shelves and sometimes rearrange themselves in the morning. Workers often reported hearing the same war cries, screams and gunfire. Figures made of a mistlike substance have also been said to appear inside and outside the building, sometimes scaring locals or visitors who are passing by.

With so much sadness and bloody history on one spot, it's no surprise that these spirits still linger at the Council House.

COMANCHE LOOKOUT HILL

Hundreds of years ago, the South Texas landscape was a breathtaking experience for all to see. Today, the land is tough and smitten with mesquite, cedar and cactus, whereas in those days, the land and the people were quite different. Before the Europeans came, there were green grasslands, and to the north of San Antonio, the hills began to roll. Covering them were buffalo that freely roamed the land alongside the Native Americans who lived and hunted here.

Entering today into the northeastern outskirts of San Antonio, you will notice the obvious differences in vegetation and in the terrain. Leaving the flat land of the city and coming north on Loop 1604, you will see the hills begin to enter into view. The beauty is breathtaking as you find yourself instantly engulfed on all sides by the start of the Texas Hill Country. As you pass along there is one hill you will notice that stands taller than the rest, right off old Nacogdoches Road, with a tall castle-like tower on top. This mysterious hill is called the Comanche Lookout Hill.

The fourth-tallest natural point in San Antonio, the Comanche Lookout Hill stands at an elevation of 1,340 feet. Since the early days, this hill has been the vantage point of the area. As the surrounding

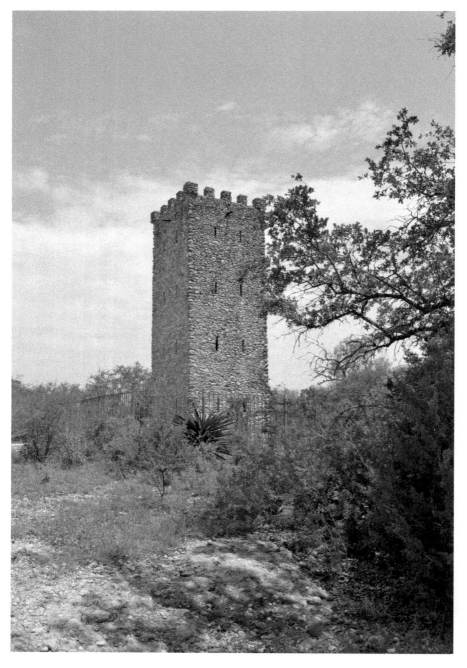

Castle tower built by Edward H. Coppock located on top of Comanche Lookout Hill.

terrain was mostly grassland during the 1700s, the hill was used by a few Indian tribes over the years. It was used mainly for hunting and warfare because from the top of the hill, one could see for miles, which was very beneficial in preparation against enemy intruders. The first Indian tribe to arrive to this area was the Apache. They ruled the lands when the first Spanish settlers arrived. Later, the Apache were conquered by the Comanche, and the hill became theirs, giving them claim and fame to the lookout.

In the eighteenth century, Spanish settlers on horseback and in wagons began to flow into the area. The hill, which was still occupied by the Comanches, was used as a landmark by travelers. Following the trails the Native Americans once used, the old Spanish road the settlers took was known as the "Camino Real," or as we say in English, "Royal Road." The Royal Road (today, Nacogdoches Road) led the early Spanish settlers from the city of Nacogdoches in East Texas to Bastrop and, finally, San Antonio. When they saw the hill, the travelers knew their future home was not too far away. Just beyond the hills was the city. Unfortunately, the Comanches often saw them coming from hours away, allowing them time to gather braves to set an attack—a constant danger for those traveling along the base of the hill. Given the higher ground of their attackers, they would often be ambushed and demolished.

As one might suspect, the settlers were not going to just sit back and be killed. For years, there was backlash, and the settlers and the Comanches constantly battled each other. They took these battles to the outskirts and even inside the city, while at Comanche Lookout Hill, there was much blood shed on both sides. Eventually, a change of power took place. The hill became property of the settlers and was used as a lookout for Indian intruders instead of Spaniards and other Anglo settlers. It was said that there was even a fort built on top of the hill.

In the early days of the republic and statehood, Comanche Lookout Hill and the area surrounding it changed ownership many times. It was eventually bought by Mirabeau B. Lamar in 1848. He served as the second president of the Republic of Texas. When the land was

passed down to his daughter in his will, he still referred to the hill as "Comanche Lookout." Because the land was never used, Lamar's heirs sold the land to two immigrant brothers from Germany. Gustav and Adolph Reeh farmed the land until Adolph died, and Gustav sold the land to retired army colonel Edward H. Coppock in February 1923 for $6,000.

Coppock, having been stationed in Europe for many years of his military career, was said to be a romantic and had fallen in love with history. Seeing many castles throughout his years of service, he decided, after buying the land, he would build his own castle on top of Comanche Lookout Hill. Enlisting the help of his sons and a stone mason, Coppock built a four-story medieval Gothic stone tower, as well as possibly another tower and the foundation for his castle. He envisioned a fairy tale of a home, but unfortunately, troubled times came between him and his castle: the Depression of the 1930s and war in the 1940s. In 1948, Coppock died, and his castle was never completed. From Loop 1604 today, when the wind blows right, the tower can be seen where it still stands. The foundation of his dream castle is all that remains on top of Comanche Lookout Hill.

In 1994, the last sale of this land and Comanche Lookout Hill took place. The Parks and Recreation Department of Texas, understanding the need to preserve history, set this land apart. Comanche Lookout Hill became a public park with many trails for walking and running, all leading up to the same peak where you can marvel at the old castle tower or look off into the horizon as so many before us have done.

From violent history to unfinished business, Comanche Lookout Hill is considered by most to be haunted. Many years have passed since the last Comanches owned this hill, but their spirits are said to roam the area, perhaps still protecting a land they once loved. Even Colonel Coppock walks these grounds, having died with his beloved castle incomplete. People today have often seen an old man with a wheelbarrow, bringing stone to and from the hill. Unfortunately, his tower has been broken into and vandalized

many times by juveniles throwing large parties and holding séances. Some of these vandals have even practiced witchcraft near his tower, trying to call back the dead on spooky Halloween nights. Not very appreciative, the colonel is said to appear from his tower looking down sternly at any trespasser who dares to approach his tower.

Walking the trails of Comanche Lookout Hill, people often feel as if they are being followed and watched from the trees by some unknown presence. In the early hours of the morning or toward dusk, people have heard voices and chanting come from within the wooded areas, sometimes even war cries. Often, shadows of men will cross pathways and disappear in the trees in silence, as if their feet did not touch the ground. In addition, sounds of drums that feel like your own heartbeat are often heard pounding on top of the hill. Reports of warm spots, signifying darker spirits, are said to be felt from the base of the hill to the peak. We believe that the Comanches are perhaps wishing they could protect their hill from intruders to this day.

During one of our tours, one of the attendees told us about an experience she had while at the Lookout Hill. Having lived near the area of Comanche Lookout Hill, Camila would walk her dog almost every evening to the top of the hill and back. Telling me she always felt the hill was different, she admitted she often heard screaming and the chanting of men coming from within the woods. Believing they were just teens messing around, she and her dog would often walk faster, but always in the back of her mind, she felt it could be something else. The last time she went for her walk, it was evening; as she walked down the hill, the trail began to darken quickly. With just less than halfway to go, Camila's dog all of a sudden turned around and stopped, hair standing up on end. Looking defensive, he began to growl. Looking back herself, she made out what seemed to be two men with painted faces. They let out a war cry and began to run toward them. She yanked her dog back immediately and took off running toward the bottom of the hill. Turning back as she entered the parking lot, the men

with painted faces had disappeared. Noticing that there were no more cars in the parking lot, she knew she must have been the last person to leave the park. Still to this day, she knows what she saw and never plans on returning to the park again.

Comanche Lookout Hill has a breathtaking view, and whether you visit it for a hike or for the history, remember the souls who once roamed the land and the man whose life was cut too short before he could realize his dream.

SAN FERNANDO CATHEDRAL AND MAIN PLAZA

In the heart of Main Plaza sits one of San Antonio's most treasured and beloved sites: the San Fernando Cathedral. It has watched over Main Plaza and its inhabitants for over 250 years. Its rich history is one of the many reasons why people come from all over to visit it.

Built by the Spanish settlers from the Canary Islands in 1755, this church was once considered the center of the city. Its dome, with a cross on top, is where all mileage in San Antonio was calculated. Its patron saints are La Virgen de Guadalupe, which is the local saint, and La Virgen de La Candeleria, the saint of the Canary Islands. Both merge the Old and New Worlds together.

When the Canary Islanders arrived to San Antonio, one of their main missions was to build and complete a cathedral for them to worship in. The king of Spain had sent them to this land to build a city before the French could reach the area and lay claim to it. When the Canary Islanders arrived, they instantly started work on their beloved cathedral. They did not get very far before the indigenous tribes of that area began to interrupt their work. These tribes were the Apache.

The Lipan Apache did not like the fact that strange foreigners had come in and taken over the lands that they had established. When

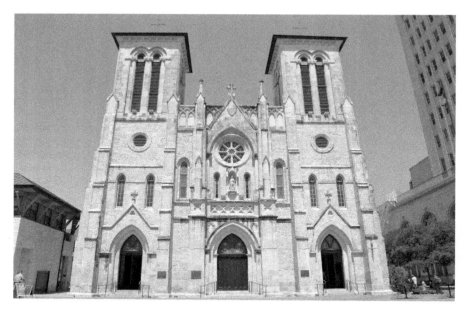

San Fernando Cathedral built by the Canary Islanders.

they saw the Canary Islanders building their cathedral and houses, they felt threatened that they would be forced to leave their homeland. In 1730, the Lipan Apache declared war on San Antonio, and attacks escalated so fast that people were warned not to leave their villas in fear that the Apache would kill them. This fear of the Apache and their raids on the city lasted almost twenty years.

In 1749, the Apache decided that they were no longer going to fight against the city and its inhabitants. In front of the San Fernando Cathedral, on its main plaza, the Apache dug up a giant hole. There, they laid their hatchets, arrows and war clubs inside as a symbol of their peace. Some have claimed that the popular phrase "burying the hatchet" comes from this ceremony. With their weapons, they also placed a living white horse inside the pit. Horses for the Apache were a very important part of their warfare, and the color white also symbolized peace. After placing the white horse and their weapons within, the Apache began to fill

Left: This photo was taken before the 1868 enlargement and remodeling of the cathedral.

Right: Photo of the cathedral taken in 1880.

in the whole. When this was completed, the Apache and Canary Islanders danced around the pit in celebration of their peace treaty. Not too long after this, the Lipan Apache were forced from their homeland by an outbreak of smallpox that claimed the lives of many members of their tribe.

After the Apache left, the Canary Islanders were able to complete the cathedral that they had spent many years laboring over. They named it San Fernando Cathedral after King Ferdinand III of Spain.

Many significant events have occurred at the San Fernando Cathedral since its completion. James Bowie, one of the defenders of the Alamo and inventor of the Bowie knife, married Ursula de Veramendi at San Fernando in April 1831. Ursula was the daughter of Juan Martín de Veramendi, governor of the province of Coahuila and Tejas. He was a very important man of his day, and he knew James through business ventures that they owned together. When James married his daughter Ursula, she was supposedly only nineteen years old, and he was thirty-nine. A few years after their marriage, a cholera epidemic struck Texas. Fearing that it would make its way to San Antonio, James sent his wife, her parents and

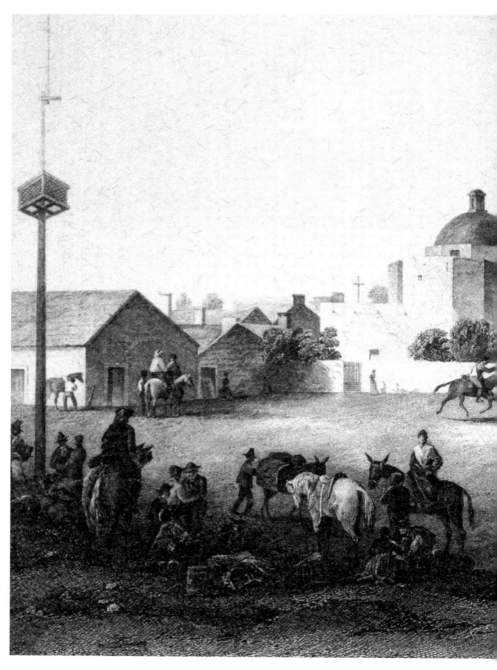

Military Plaza and the view of the San Fernando Cathedral in the early 1800s.

their children to the family estate in Monclova, Mexico. Sadly, the cholera epidemic hit Monclova instead, and within a few days, the whole family was dead.

They say James was never quite the same after he found out the horrible news. Apparently, he took up heavy drinking and didn't care for himself. He often looked very ragged and worn. Later on, James contracted yellow fever and died with the rest of the defenders inside the Alamo. Inside the cathedral today, in a white marble sarcophagus toward the front entrance, the remains of James Bowie are said to be found.

The San Fernando Cathedral also played key parts in the battle for Texas's independence. When Santa Ana marched into the city, he made his encampment beside the cathedral. He even raised the blood-red flag of no quarter from the cathedral's tower—symbolizing to the defenders of the Alamo that there would be no prisoners or mercy shown to them. After the Texans won their independence, they flew the victory flag from the same tower.

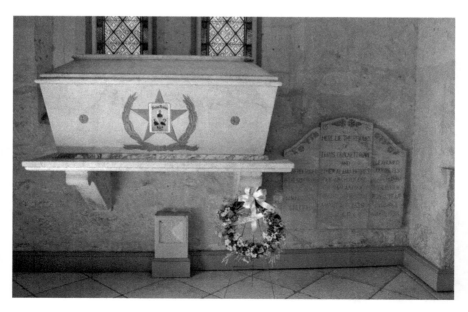

The sarcophagus in which it is claimed the remains of James Bowie, William Travis and Davie Crockett are located.

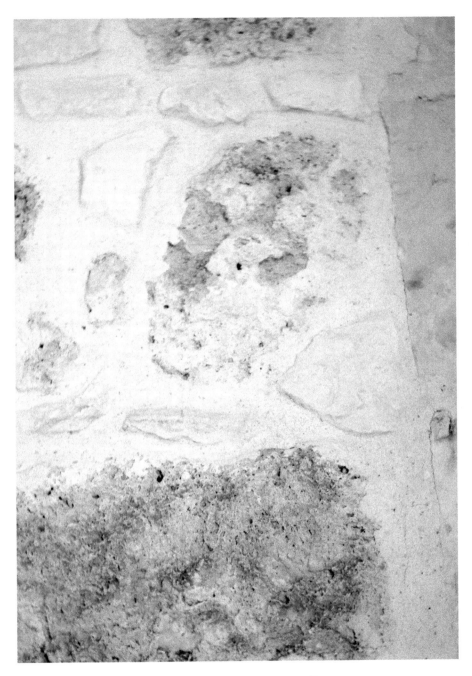

Skull face that appears on the back of the cathedral walls.

A photo taken from the back walls of the cathedral of an unknown figure appearing near the door. *Courtesy of Santa Gene.*

Inside the cathedral today, there are actual people buried within the walls. They range from high-ranking men to a small child. All have been entombed inside the oldest walls of the cathedral, which is considered the oldest standing structure in Texas. Because of this, people have claimed to see faces appear in the walls. There is one face that appears the clearest of them all. On one of the rock surfaces, there is a distinct skull-like figure peering from the side of the back door. Its eyes, nose and mouth can clearly be discerned from the rest of the rock wall.

When people take photos inside and outside the cathedral there are usually many orbs seen all throughout the area. One night, a guest on our ghost tour took a photo of the front of the cathedral. The photo showed what appeared to be a woman-like figure in a long dress, floating above all our heads as we did the tour. On a different occasion, one woman asked us about a strange man who followed the tour from the front of the cathedral to the back and disappeared. She said he was dressed from head to toe in black period dress with his hair slicked back. At first, she thought it was another tour guide from our company joining in, but when the tour went around the back of the cathedral, he had vanished. Two other people on the same tour claimed they had seen the same man.

Also toward the back of the cathedral, dark figures have appeared and disappeared. Some people have taken photos in the area and have seen these shadows near the walls and hiding next to the doors. Some

have even appeared with hoods over their heads, similar to what a monk would have worn.

The San Fernando Cathedral will always be a center of history and culture in the city of San Antonio. The spirits that surround it seem to love this cathedral as much as the living.

CHAPTER SIX

BLACK SWAN INN

S ituated on top of a natural knoll overlooking the Salado creek sits a majestic plantation home with a bloody past and ghostly sightings. With towering antebellum columns and a majestic arched doorway, not even Hollywood could have made a more picturesque haunted house. Now known as Victoria's Black Swan Inn, this home and its acreage have quite a story to tell.

Off to the distance from the house sits a historical Texas land marker that commemorates the battle that occurred on the now peaceful and lush landscape. It reads:

> *The Battle of the Salado*
> *Decisive in Texas History, was fought here, September 18, 1842. Col. Mathew Caldwell and Capt. John C. Hays, commanding a force of Texas volunteers, opposed the Mexican army under General Adrian Woll that had captured San Antonio, and, with the loss of only one man, checked the last Mexican invasion of Texas and thereby prevented the capture of Austin, capital of the Republic of Texas.*

The battle was Mexico's second attempt to take Texas back after it had previously won its independence. The attempt failed, and a

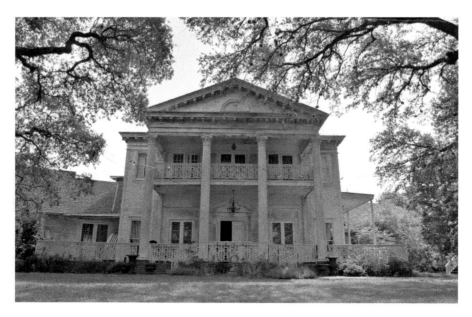

Photo of Victoria's Black Swan Inn.

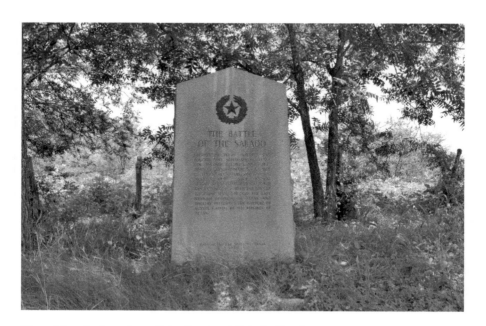

Texas historical marker of the Battle of Salado Creek.

bloody battle occurred on the grounds of the Salado Creek with over sixty Mexicans losing their lives as well as one Texan's death.

Years later, a prominent German family named the Mahlers fell in love with the land and decided to purchase it for $2,200 in 1887. They built a beautiful house on top of the knoll and lived there for years. A few other families came and went as the years passed. With each move, the new family renovated and made the main house even more grand and stately. In the 1950s, a wealthy and famous couple of San Antonio moved into the house after a parent had passed on. Park and Jolene Street were San Antonio's socialite couple, and together they held many grand and lavish parties inside their beautiful estate. Some of their most notable guests were Earle Stanley Gardner and Raymond Burr.

Sadly, the young couple's happiness and lavish parties did not last. Jolene Street suddenly passed away from cancer in her late thirties. Park was devastated and never quite got over his beautiful wife, who died at such a young age. Park did eventually remarry, but he often suffered bouts of depression and had to undergo psychiatric treatment in Galveston to help him control these attacks. Sadly, one morning in 1965, he was found by his second wife strangled to death with a belt looped around a bedpost and his hands tied behind his back. It was later concluded that he had committed suicide, although some claimed it was murder. And so the Streets' lavish and flamboyant lifestyles died with them.

Today, the house is known as Victoria's Black Swan Inn and is host to weddings, private events, conferences and parties.

Although the home has had many owners over the years, it seems that the Streets have never left their beautiful mansion.

The owners of the estate today report strange happenings in almost every part of the house. A faint medley of piano music is often heard coming from some of the rooms. Laughter and voices are accompanied by it, and when checked, there is nothing there. It seems as if the Streets are still throwing their lavish parties inside their manor.

In another room, children's dolls are often rearranged in the morning as if someone had been playing with them throughout the night.

Front porch of Victoria's Black Swan Inn.

There is a presence of a man that has scared many of the guests who stay the night. His face is seen in one of the upstairs bedrooms through the window. He is described as being terrifying and almost demonic looking. He stares at his guest angrily as if they are not wanted. And he seems to have succeeded, because no one wants to stay there.

There are sightings by the staff of the inn who claim that a woman in white with dark hair is seen walking out of the house and on the knoll toward the gazebo. She often stops and looks as if she is pondering something and then disappears. She does this so often that the staff have grown quite accustomed to her and the sightings. She looks eerily similar to the past mistress of the house Jolene Street.

Victoria's Black Swan Inn is so haunted that many paranormal investigation teams have stayed the night to investigate. It has also been featured on many television shows, and today, the owner of the house conducts monthly investigations.

Activity has never been so high as it is right now at the inn. It seems as if the past ghosts welcome the visitors and often enjoy showing the living that they still exist and love their home.

CHAPTER SEVEN

SAN ANTONIO VICE

During the days of the Old Wild West and after the fall of the Alamo, San Antonio surprisingly became a popular tourist destination. Before the river walk existed or the many tourist shops in the area that we have today, San Antonio still had one main draw: the Alamo. People loved to come and see the old fort where many men lost their lives and defended their freedom. But the Alamo was not the only popular destination in San Antonio in the late 1800s; there was one sinister spot that drew thousands of men each year. It is what almost all men came for during those days: to visit the most vice-filled part of the city, the famous red-light district.

Some actually believe the term "red-light district" was coined in San Antonio from the early days of the railroads. Areas of prostitution typically formed near the tracks for workers of the railroad to more easily patronize. Most carried with them signaling lamps (fitted with a red or a green lens) to the brothel. As they would go into the establishment, the signaling lamp would be placed outside the brothel to signal to others that the prostitute was occupied or to signal to other railroad workers where their co-workers were. Red lenses of course caused red lights, hence the phrase.

Although beginning much earlier, San Antonio's red-light district was officially established in 1889 by the city council to contain and regulate the vice. The city officials were said to "not officially condone the activities but rather unofficially regulate them." To sound more appealing and gentleman-like, the red-light district took up the official name "the Sporting District." The Sporting District became the designated area for brothels, gambling parlors, saloons, dancehalls and other similar vice-oriented businesses. Instantly, the area was a big hit and obtained fame from all over.

With San Antonio sitting in the middle of the Chisholm Trail, ranchers and cattle herders would always make their way to the city as frequent visitors. Most of the men of those days spent long months on the road sitting on top of a horse working hours without any fun. Most of them had only a few thoughts in mind when they came to nearby cities: money, booze and, of course, women. San Antonio, having many vice-filled establishments, became the place to stop and release such energy before continuing on with the cattle drive. Even some of the most famous outlaws and lawmen during their time would wind up here as well, all coming together with the same purpose in mind: to relax and have an enjoyable time.

Many years passed by, and the Sporting District still continued to thrive in the city. With many brothels and saloons, by the early 1900s, the Sporting District was one of the largest in the country—third largest, to be precise, and the largest in Texas. These were known as the glory days, and the beer, whiskey, champagne and money flowed freely. The red-light district was an extremely lucrative area. Businesses provided the city annually with almost $50,000 in licensing fees for saloons and brothels. In today's money, $50,000 is equivalent to just about $1.23 million. In 1920, there were over one hundred licensed brothels doing business there.

At that time, the main sporting area (not including the many smaller vice areas of town) was confined to a fifteen-block perimeter. A tourist guide (which will be mentioned momentarily) stated where the boundaries were located:

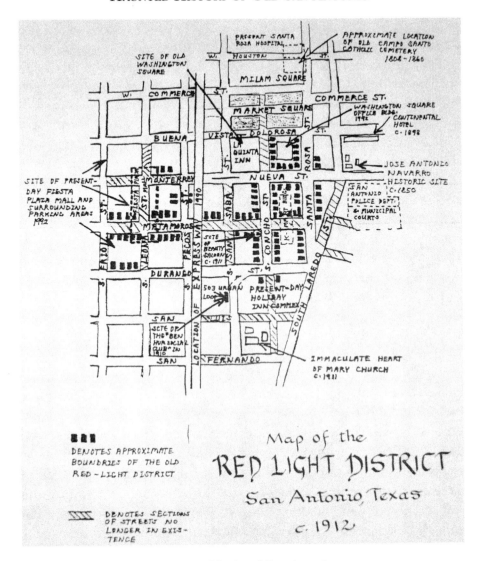

Hand-drawn map of the Sporting District of San Antonio.

South on South Santa Rosa Street for three blocks, beginning at Dolorosa Street, thence from the 100 block to the end of the 500 block on Matamoras Street, thence from the 200 block to the 500 block on South Concho Street, and lastly the 100 block on Monterey Street. This is the boundary within which the women are compelled to live according to law.

So with the large boundaries set, and the area so popular, it was difficult for visitors to get around without being overwhelmed with such short time. Conveniently, in 1911, a tourist guide appeared on the market. The author, presumably Billy Kielman, wrote a famous guide known as *The Blue Book* with the statement below the title, "For visitors, tourists and those seeking a good time while in San Antonio, Texas." It was available for anyone to buy. They were sold at basically any local corner store across town for the price of twenty-five cents.

The Blue Book was most helpful for visitors, especially for those seeking the affection of a woman. Besides the many advertisements for saloons and restaurants, you will find three specific lists: Class A, Class B and Class C. That is how the brothels and the women who worked in them were categorized.

Class A women were the most elite of all prostitutes. They were the safest to buy with no chances of catching a disease. They were the most beautiful women and were the most expensive with a price of five dollars and up. Perhaps the most interesting bit of info is that the women had to fall into a weight class, 160 to 200 pounds, because their larger frames indicated that the women were healthy. They often resided in large parlor houses furnished with the latest European and American styles and the finest art pieces. Red velvet upholstery and curtains, oriental rugs and crystal chandeliers were in abundance. Some of the most famous madams were "the Duchess" (rumored to be European royalty), "New Orleans Katie," "Midnight Ruby" and "Madame X." One of these madams supposedly collected payment only in diamonds. Another famous madam enjoyed taking fancy carriage rides on Sunday afternoons to the opera house and attending local events to the horror and disgust of the local high society.

Class B women were the "average man's" prostitutes. They were not too expensive or too cheap. Priced between $2.50- $5.00, this class had the smallest number of listings in the blue book. Your chances of going back to your wife and children without a disease were quite fair. Their businesses were usually located above bars and saloons.

Class C women were the riskiest of them all. Your chances of getting sick with venereal diseases were quite high. Costing as low as pennies

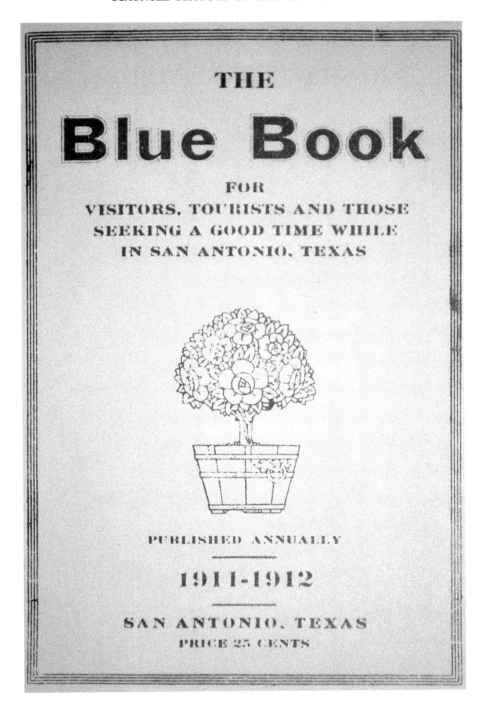

The front cover of the 1911–1912 edition of *The Blue Book*.

DIRECTORY OF HOUSES AND WOMEN

Class—A

NAME	STREET	Old Phone	New Phone
Arlington, The	507 Matamoras		1035
Benedict, Beatrice	421 Matamoras		2371
Benedict, Beatrice	309 South Pecos		2133
Benedict, Beatrice	501 Durango		499
Campbell, Maud	217 South Santa Rosa		563
Carson, Belle	526 Matamoras	4480	
Clarke, Hazel	316 South Concho		48
Clifford, Marguerite	212 South Concho	308	523
Clifton, Mildred	507 Matamoras		1035
Club, The	502 Matamoras		453
Evans, Eva	505 Matamoras		2096
Granger, Dollie	502 Matamoras		453
Lavigne, Bonnie	520 Matamoras		456
Mansion, The	503 South Concho	1964	896
Meyers, Emma	316 South Leona		5268
Ray, Frankie	317 South Santa Rosa		1779
Revere, Lillian	514 Matamoras	1357	1888
Russell, Clara	504 South Concho	1964	896
Stag, The	520 Matamoras		370
Smith, Aggie	212 South Concho	308	523
Thaw, Evelyn	316 South Concho		948
Tripp, Grace	313 Matamoras		1034
Wiley, Emma	316 South Concho		948
Williams, Marguerite	316 South Concho		948

21

Blue Book: Class A brothel listings.

Class—B

NAME	STREET	NEW PHONE
Baxter, Hattie	317 South Concho	2911
Brooks, Irene	521 Matamoras	
Cottage, The	421 Matamoras	
Day, Bessie	408 Matamoras	
El Toro	309 South Pecos	2133
Epps, Bertha	317 South Santa Rosa	1779
Foster, Daisy	315 Matamoras	3160
Hudson, Madge	214 Matamoras	2125
Howard, Etta	407 Matamoras	
Lewis, Grace	409 Matamoras	3134
Meyer, Vera	426 Matamoras	2641
Morgan, Minnie	309 Matamoras	1704
Pruitt, Frances	317 South Santa Rosa	1779
Raymond, Edith	309 South Pecos	2133
St. Clair, Belle	410 Matamoras	962
St. Paul, The	309 Matamoras	1704
Silver Slipper, The	410 Matamoras	962
Sharpe, Grace	217 South Santa Rosa	563
Singleton, Myrtle	317 South Santa Rosa	1779
Three Twins, The	309 South Pecos	2133

23

Blue Book: Class B brothel listings.

Class—C

NAME	STREET		NEW PHONE
Brewer, Sallie	216 South Concho		1952
Dupree, Anita	320 " "		1952
Durant, Marian	320 " "		248
Duval, Aleese	307 " "		1605
Duval, Cecile	312 " "		
Duval, Georgette	226 " "		
Denman, Pebble	224 " "		
Davis, Ada	224 " "		
Edwards, Bessie	405 " "		2344
Garza, Margarita	410 " "		
Jennings, Grace	305 " "		248
Kato, Tama	220 " "		
Legal, Tender	216 " "		
Lomax, May	403 " "		2344
Mack, Lea	303 " "		248
Maxine	403 " "		2344
Ray, Blanche	314 " "		
Smith, Marcella	226½ " "		
Sullivan, Crickett	407 " "		2344
Yoshima, Sada	220 " "		
Dixie, The	209 Matamoras		3157
Brown, Annie	217 "		
Black, Mary	215 "		
Carr, Marie	205 "		
Burkhart, May	204 "		
Brown, May	210 "		
Garcia, Julia	216 "		2161
Hesskew, Annie	217 "		
Harris, Marguerite	204 "		
Hooper, Mabel	206 "		
Jones, Helen	205 "		

25

Blue Book: Class C brothel listings.

at times, they were considered pocket change. The women were seen as the least attractive but, surprisingly enough, the most patronized. They lived in little shanties outside the district and would often sit outside to lure and entice men inside. While the other classes were at least one page in length each, Class C took up more than double the space. We could assume that they worked quantity over quality.

The Blue Book was widely used. It even brought fame to one establishment in particular. This business of vice was called the Beauty Saloon. It was owned by a man named Billy Kielman. He was once a Rough Rider under Teddy Roosevelt and even a San Antonio police officer for some time. Assuming a new way of life, he moved in with a lady of the night and began his own establishment. If you remember, he presumably wrote *The Blue Book*. Advertising himself, he became famous and so did his business, especially because his ad on the back cover of *The Blue Book* had a poster of himself and a phrase that read, "For Information of the Red Light District Ask Me. Meet me at the Beauty Saloon." Before visiting any sites, people came right to his

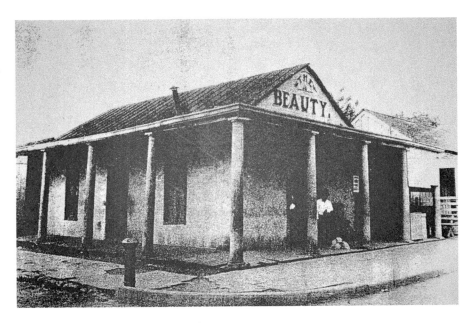

Billy Kielman's famous Beauty Saloon.

Beauty Saloon for information on having a good time in the city. He soon became the wealthiest man in San Antonio. Billy was a likable and popular person but a little rough around the edges. He was a good pistol shot and a great fistfighter as well. He later died in a shooting incident while he was running the Horn Palace Saloon.

Another well-known establishment was Fannie Porter's Sporting House. Owned by Fannie Porter, one of the most famous madams of the West and an English immigrant, she built her brothel a block outside the borders of the red-light district. Still standing to this day, the building is located at the corner of Durango (Cesar Chavez) and San Saba Street. Her brothel became well known in the area as a Class A establishment owned by a woman who was well respected. She handpicked the prettiest girls ranging from the ages of eighteen to twenty-five to work for her, and she required that hygiene be practiced. As a lady of privacy, she respected her clientele and because of that her establishment quickly became a safe haven and hideout for some of the most famous gunslingers and outlaws. Butch Cassidy, the Sundance Kid and the Wild Bunch were frequent visitors of Fannie's, along with others such as Kid Curry. While Butch Cassidy was in San Antonio, he used to amuse Fannie and her girls by performing fancy acrobatic tricks on his bicycle as he rode up and down the street. Years later, the famous actor Paul Newman re-created this scene in the 1969 movie called *Butch Cassidy and the Sundance Kid,* which also starred Robert Redford. The edifice in which Fannie ran her brothel is one of the only buildings that once housed brothels that still exists today. It is located at 503 Urban Loop and is used today as an emergency shelter for teenage boys.

The red-light district was not always as glamorous as it appeared. Amid the fine living and beautiful luxuries these women enjoyed, there were many scandals and tragedies. Drugs were very rampant in the vice-filled areas, especially morphine, cocaine, opium and laudanum. Morphine was said to be cheaper than a bottle of whiskey at times. The leading cause of deaths for prostitutes in those days was suicide.

One tragic story to occur of this nature was to a young girl by the name of Nellie Clemente. It is said that Nellie was thirty-two years old

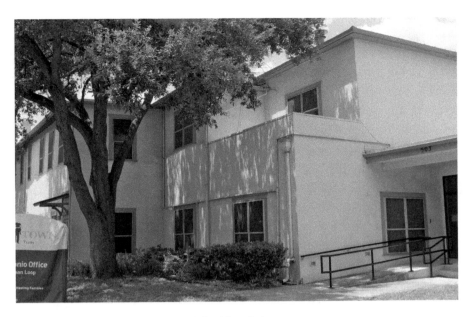

Current site of Fannie Porter's original brothel.

and had come to San Antonio from Los Angeles. In 1896, she lived in the red-light district as a prostitute and an actress at Washington Variety Theater. They say after her heart was broken by her suitor, she committed suicide with an overdose of laudanum. She was just another tragic victim of her society.

In 1941, the red lights of San Antonio's famous Sporting District began to dim. Brothels no longer were a suitable place for young servicemen to visit, and the nearby military bases made them off limits. The man credited for closing down the red-light district was President Dwight D. Eisenhower. At that time, he was commander of Fort Sam Houston and was highly disturbed by the lack of cleanliness and morality of his soldiers, many of whom came back to base infected with venereal diseases. San Antonio being a military city, Eisenhower had his way, and the red-light district was officially shut down for good.

Some say the Sporting District never really went away. The spirits of those wasted human lives still seem to linger and haunt the area of the old red-light district. Almost all the buildings that were built

as brothels and saloons have all been destroyed over the years and so have their history. Neighborhoods, local shopping malls and hotels have been put up in their place. Looking today at the many blocks that it once consisted of, you would never guess that such vice once existed. However, there still remain two buildings in the area that have not been destroyed and have kept a little piece of their histories alive.

The first building is Fannie Porter's famous brothel that sits on 503 Urban Loop. Today, it is Father Flanagan's Boys' Town. The building is a shadow of its former self but still carries traces of what it once was. It is reported to be haunted by the spirits of the women who worked there and the outlaws who frequented it. Some people have claimed to see a beautiful but sad woman appear on the grounds of the building. She is seen walking outside, circling the property, and is said to wave as you pass by. Others have reported feeling cold spots inside the building and hearing soft, sweet singing coming down the hallways. Fannie's ghost is also said to appear in some of the nearby rooms, apparently carrying on with her usual duties of looking after her girls. Curious guests who have driven past the house and taken photos have captured orbs as well as a cloudy woman-like figure near the front door. This is perhaps the same lady of the night who wanders the outskirts of the former brothel. Butch Cassidy is even still seen riding his bike up and down Urban Loop Street, as if he is still trying to impress Fannie Porter and her beautiful girls.

The other house that is still in existence was not formally a brothel but once served as a saloon. The Casa Navarro sits inside the limits of the old red-light district and is today a beautiful museum. Originally built in 1832 by Jose Antonio Navarro, it served as the Texas patriot's homestead until his death in 1871. Afterward, it was sold and used as a bar or saloon in the late 1800s.

They say that a few ladies of the night worked there during that time period. We can only imagine they would have belonged to the Class B list of prostitutes as they were generally known to work above bars or saloons.

In 1960, the house was turned into the museum that you see today located on South Laredo Street. The purpose of the museum is to

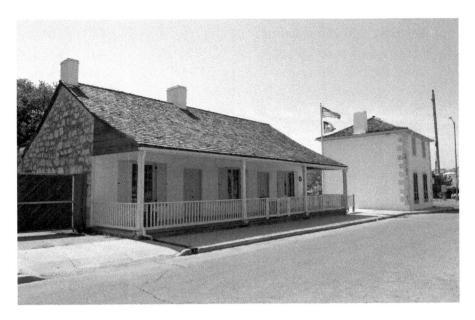

Casa Navarro state historic site.

show the history of the Navarro family in San Antonio and their contribution to the Texas Revolution.

At night, after the museum is closed up and visitors have left, the original houseguests can be seen roaming the property. One in particular, and the most often sighted, is that of a woman dressed in white walking about the perimeter of the house. She is said to be the spirit of a young prostitute murdered there when she worked at the saloon. It is said that one of her jealous clients was responsible for cutting her life short. Since then, her spirit has been seen roaming sadly about the property looking as if she is lost. She is sometimes even seen inside the house, peering through windows. When we originally took our tour groups to this house at night, there were a few occasions when the lights inside the house would turn on and then turn off, as if someone was trying to notify us of her existence. When we spoke to the curators of the museum, they assured us that no one was inside the house that late in the evening. Perhaps these occurrences are from the spirit of this young girl, letting us know she is still around.

The red-light district is gone, but it seems its ghosts still remain. At night, if you listen carefully, they say you can faintly hear the echoes of loud laughter, pianos playing "Ragtime" and, farther down the street, some mournful blues echoing out from a long-vanished saloon. The city has tried very hard to get rid of any traces of what it once was, but the spirits refuse to fade away.

THE EMILY MORGAN HOTEL

Inside the Alamo Plaza stands a tall, majestic building with Gothic architecture and a spooky aura around it. It is the Emily Morgan Hotel, considered to be one of the most haunted hotels in San Antonio.

This hotel bears the name of one of San Antonio's most iconic legends: Emily Morgan. Originally called Emily West, she was born a free woman of mixed race in New Haven, Connecticut. In 1835, Emily was contracted to James Morgan to work as an indentured servant for one year at the New Washington Associations Hotel as a housekeeper. Several months into her indentured servitude, on April 16, 1836, Emily and other servants were kidnapped by Mexican calvary. Emily was forced to travel with the famous General Santa Ana and his army as they prepared to take on the forces of Sam Houston. Legend says that on the day of the Battle of San Jacinto, as Sam Houston and his men were riding in, General Santa Ana was taken off guard and unprepared to fight. He was being entertained by the lovely Emily Morgan during his siesta inside his tent. Some go as far as saying that Emily Morgan helped the Texans win their independence within eighteen short minutes. Although there is no official account of a woman in the general's tent at the time, there

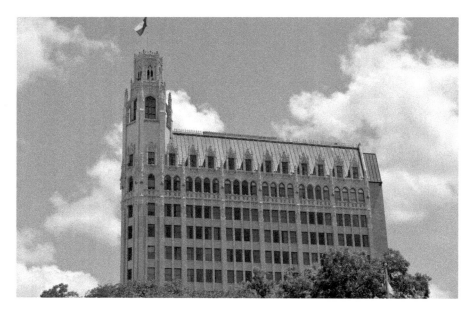

The Emily Morgan Hotel.

did appear a journal entry written in 1842 by British traveler William Bollaert, which started the legend of Emily:

> *The Battle of San Jacinto was probably lost to the Mexicans, owing to the influence of a mulatto girl belonging to Colonel Morgan, who was closeted in the tent with General Santa Ana, at the time the cry was made, "The enemy! They come! They come!" She delayed Santa Ana so long that order could not be restored readily again.*

Although the loss of the battle is officially attributed to the carelessness of Santa Ana, the legend of Emily Morgan began to grow and is now considered to be the main theme of a popular Texas song, "The Yellow Rose of Texas." Below are a few verses from the popular song:

> *There is a yellow rose in Texas, that*
> *I am going to see,*
> *No other soldier knows her, no*

Soldier only me
She cried so when I left her it like
To broke my heart,
And if I ever find her, we nevermore
Will part.

(Chorus)
She's the sweetest rose of color this
Soldier ever knew,
Her eyes are bright as diamonds, they
Sparkle like the dew;
You may talk about your Dearest May,
And sing of Rosa Lee,
But the Yellow Rose of Texas beats the belles of Tennessee.

Her legend lives on through this song.

The Emily Morgan Hotel was first built as a private medical building by J.M. Nix in 1924. It was built after the Gothic style that was the fashion for skyscrapers in the 1920s. Perhaps the most interesting part of the building are the terra-cotta gargoyles on the side of the building, depicting figures with various ailments, such as toothaches and other medical troubles. This was the first doctor's building in the city, and it was said to be able to accommodate one hundred doctors and office space for four hundred.

In 1976, the doctor's building was converted into an office building, and in 1984, it was bought and made into the Emily Morgan Hotel. Today, as guests relax and sleep inside this hotel, they claim that they do not feel alone.

The most haunted floors are considered to be the seventh, ninth and fourteenth floors as well as the basement area. These floors used to serve as a psychiatric ward, surgery floor, waiting area and the morgue.

Strange occurrences seem to happen to guests staying on these floors. Some people have claimed feeling something brush up against them when staying inside the hotel and feeling cold spots in certain

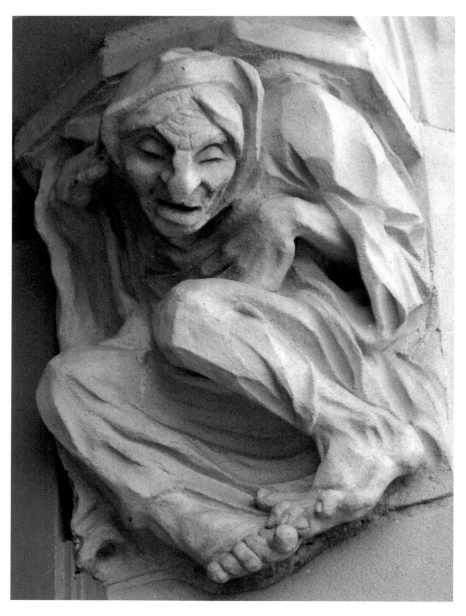

One of many original terra-cotta gargoyles located on the outside of the Emily Morgan Hotel.

places in their rooms. There are guests who claim when they opened their doors into the hallway, there lay before them a scene from a hospital playing out before their eyes. When they closed the door and reopened it, the scene has vanished and a normal hotel hallway was seen again. For some reason, the bathrooms of these certain floors have a lot of activity in them. People have been woken up during the night hearing their bathroom doors open and close and faucets turn on and off as well as seeing lights flashing. When inspected, suddenly everything stops and is back to normal.

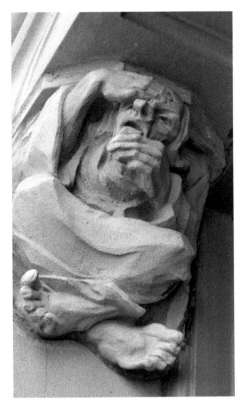

The gargoyles depict different ailments.

A mother and daughter on our tour recently told us that one night when they were staying at the Emily Morgan Hotel, they had quite a frightening experience. The daughter was getting ready to go to sleep as her mother waited in bed. The mother felt a body weight enter the bed with her and, thinking it was her daughter, turned and said, "You forgot to turn off the bathroom light." To her astonishment, the daughter came out of the bathroom and said, "Hold on a sec. I'm not done yet."

Fear struck the mother as she looked at the form lying beside her. She could see the sheets raised up as if there were an actual person in bed with her. Suddenly, the sheets fell, and the weight lifted off the mattress. But the mother could see no one. The presence left, and so did the mother and daughter; they decided to change rooms.

Another experience related to us was by a little girl who stayed at the Emily Morgan with her family. She said as everyone was sleeping, she was suddenly awakened by a presence of something standing beside her. She could see the tall outline of a dark figure looking down at her, but it had no facial features. The thing seemed to be beckoning her to follow it outside, as it was pointing to the door. Frightened, she covered the sheets over her head and waited to see if it would disappear. A few moments later, she felt the presence disappear. Who knows what would have happened to this little girl had she followed the shadowy figure.

The elevators at the hotel seem to have a life of their own for they like to go up and down the different floors with no one in them. The front desk often receives a lot of anonymous phone calls, and when they are traced, they are coming right from those elevators. Now sometimes, these elevators will not let their guests out; they will just stay shut for hours on end.

The basement where the morgue and crematorium were once located is not a very popular place for employees. Many unusual occurrences take place within the area involving strange sightings of orbs floating through rooms and hearing footsteps and voices. Sometimes, people claim that they can still smell the stench of bodies being burned from that area. The elevators love to visit this place. They most often take their guests by surprise and bring them to the haunted lower level.

On the seventh floor of the hotel, people are sometimes awoken to a woman screaming in the hallway. Her voice seems to carry throughout the hotel and people are often very frightened by its presence. When notified, the staff has made sure to check for the whereabouts of this voice. But it never seems to be found.

The Emily Morgan and its spirits are what make it one of the most haunted sites in San Antonio today. If you are brave enough to stay there, you might just have a ghostly experience yourself.

THE HOTEL INDIGO

The Hotel Indigo sits inside Main Plaza right across from the Alamo, almost hidden from the view of all the tourists and locals who visit the downtown area daily. It is a majestic old building that stands somewhat tall, with architectural details from the early 1900s. The Hotel Indigo is not a famous hotel nor does it call too much attention to itself. It is somewhat overshadowed by the fame of the Menger, which sits close by. The Menger Hotel has a rich history unto itself, but it does not sit on the original grounds where the Alamo once stood. Only the Hotel Indigo can lay claim to this, and little do people know what exactly transpired on these grounds. If the earth could speak, it would have many stories to tell about that portion of land.

The northwest corner of the Alamo, where the Hotel Indigo stands today, was hit the hardest on March 6, 1836. This is where Santa Ana and his men first gained entry inside the Alamo and is also where the heaviest bloodshed occurred. In accounts written by people who later on saw the aftermath, it is claimed that the northwest corner was filled with so many mangled bodies that the ground was literally soaked with blood. On this corner as well is where the famous William Travis was shot and fell dead. The spot where he fell is where the hotel's front desk stands today. The battle of the Alamo was over

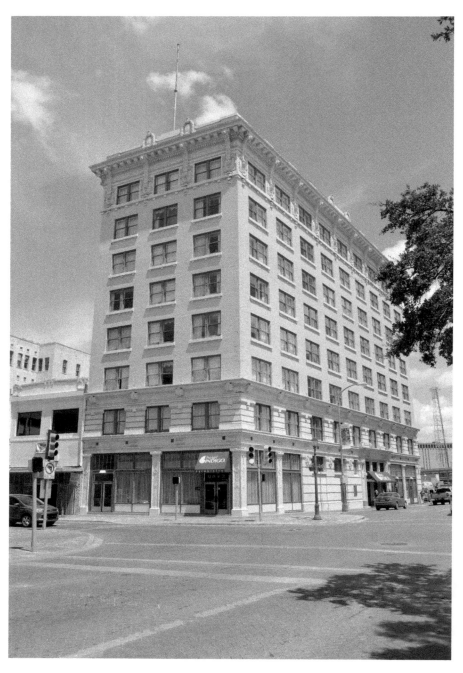

The Hotel Indigo, formally known as the Gibbs Building.

within ninety minutes and left behind horrific bloodshed. Samuel Maverick, who was at the Alamo, was emotionally drawn to the place and is reported to have said, "I have a desire to reside in this particular spot. A foolish prejudice, no doubt as I was almost a solitary escape from the Alamo massacre." He decided to build his homestead at the old northwest corner. Later on, in 1909, a Southern Pacific Railroad executive named Colonel C.C. Gibbs built the first high-rise office building in the city, known as the Gibbs, on the same spot. Today, it is the beautiful Hotel Indigo.

With so much history and bloodshed on one spot, it is no wonder why the Hotel Indigo reports strange activity within its walls. Guests have often reported hearing canon and gunfire inside the hotel as well as screams of agony and shouting. When the Gibbs building was being constructed, workers found in the basement two canons from the battle of the Alamo. Since they have been removed, activity has seemed to peak. One of the security guards at the neighboring U.S. postal office said that one night, he saw through the window two men

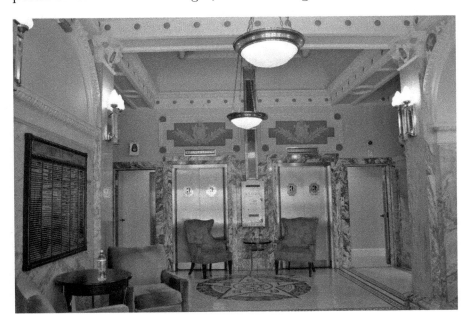

Original lobby and elevators of the Gibbs Building.

pushing a canon from the Hotel Indigo across the front of the post office. He thought nothing of it—there are so many reenactments in front of the Alamo—until the metal detectors went haywire at his post. Turns out, there were no reenactments that night in front of the place. Guests feel a lot of energy inside the basement and hear strange voices as well as footsteps. I myself have felt a different energy down there as well.

The original elevators inside the hotel are no longer in service, but they are a beautiful testament of old architecture from the turn of the century. Although the elevators clearly state they are no longer in service, guests are often confused; they swear they just saw someone using them a moment before. Guests also see people dressed from another time period walking down the hallways and entering different rooms, sometimes even their own. When they investigate, the person(s) have disappeared. Footsteps and voices are heard both day and night in those same hallways. Some people have even felt the presence of someone watching them while they are asleep in their rooms.

The next time you are in San Antonio, remember the Hotel Indigo. Its tragic history and restless ghosts are sure to welcome you.

THE OLD BEXAR COUNTY JAIL

On the cross streets of Commerce and Camaron lies a building that most people believe to be very haunted. The bars on the front windows and the old-style architecture whisper of another time when this building played an important part in San Antonito's history.

In 1878, the City of San Antonio was in desperate need of a new jail to house its ever-growing population of prisoners. Alfred Giles was hired to be the architect, and he designed a two-story limestone building that held twenty cages for its occupants. Due to the location of the new jail, it was soon nicknamed "the Shrimp Hotel" (*camarón* is Spanish for "shrimp"). One year later, the jail was completed and ready to check in its very first "guests."

Throughout the jail's history, expansion for the building was continually necessary. After a few decades went by, San Antonio's population had grown enormously, and with that growth had come the need for a larger jail. So in 1911, Henry T. Phelps was commissioned to build a third floor to the Bexar County jail, and in 1912, it was finished.

As he designed and built the third level, very original attributes were added inside that were not normally found in a jail of this time. For instance, the gallows were built inside the building, instead of outside, as was the custom.

The Holiday Inn Express and former Bexar County jail.

In those days, hangings were normally seen as a social event. Businesses would close, children were let out from school and the whole town would gather to watch. However, in the current design of Phelps, that form of amusement was left out. The gallows were redesigned to be on the third floor of the building, for a more private viewing. Only a select group of individuals (family, jury, etc.) would be permitted to watch.

With the new design, the prisoners were led up to the third floor and placed over a trap door. While on the trap door, a hood was placed over their heads and the noose around their necks. The lever would then be pulled, and the unfortunate soul would drop to the second level, where an audience of one hundred or more watched on. Also watching the hangings were the prisoners whose jail cells lined the area, perhaps to see the consequences of their actions.

In 1926, expansion was once again needed, and Atlee and Robert Ayres, a father-and-son duo, added on an additional two floors for a grand total of five floors. Also designed was the arched entrance porch that we see today.

The Bexar County jail shares much history as a building, but within its walls, the jail contains tragic stories of prisoners, riots and many hauntings. But there is one person and one event that stand out among the rest. This is the story of the last public hanging in San Antonio.

There is a popular phrase uttered by the aging generation in San Antonio: "la chansa de Apolinar." What does it mean? It can be translated to mean "the luck of Apolinar." Although that doesn't seem to make much sense to most, in Texas—most commonly, in San Antonio—it does. We know it to mean, "Not a chance in hell." The phrase was coined after Clemente Apolinar became the last person to be hanged inside the old Bexar County jail. The phrase came about due to people believing that Clemente should have been freed and had no chance of winning in court, or escaping the gallows. Some call the hanging an act of injustice, but on the other hand, some might believe he got what was coming to him. We will let you decide.

It was a hot summer day, August 16, 1921, when Clemente, a young Mexican American, was taking a route from a relative's home in

Floresville, Texas, to San Antonio. (Driving today, the journey is long, but on foot, his travel could have taken more than twelve hours.) The summer was hotter than usual, and he became very thirsty. Luckily, he knew the area quite well and had made this trip several times throughout his twenty-nine years of existence; he even had a favorite spot to rest where he could fetch some water to drink.

He came to a small spring that branched from the Salado Creek. (Today, we know this area to be where Interstate 10 crosses with Roland Avenue.) During those days, the creeks and rivers were filled to the brim and springs were plentiful. Where he stopped was his own personal oasis. He knew this spring to have the freshest and best tasting of all water in the area.

As Apolinar approached the bank, he kneeled down and quickly realized that the water appeared to be extremely muddy. Of course, he could not drink such filthy water and left the bank extremely angered, wanting someone to blame. He felt that someone got there before him and maliciously stirred up the riverbed, making the water undrinkable. So, swiftly Clemente went up stream to find that person and show him a lesson.

Not too far up, Theodore (fourteen years old) and Kirby (twelve years old) Bernhard, brothers, decided to take a rest as well. In the hilly East Side pasture near the old Bem Brick Yard, the boys were herding cattle and went down to the water to play. They were racing their little toy boats down the current, when out of nowhere Clemente appeared.

In Clemente's hands, he held a large rock. Screaming and yelling at the boys, he chased them away from his water. Of course, Clemente felt that those two young boys were the culprits, and he was out to get even. After a small chase, Clemente caught up with Theodore. He took the large rock he was holding and smashed it over the young boy's head. Over and over again, he smashed the boy's skull, cracking his cranium until the boy was dead.

But Clemente was far from finished. Still going through the emotions of his vengeful rage, he began to savagely mutilate the body. He took out his knife and cut the boy ear to ear, down the bridge of

his nose and around to the back of the neck, even cutting open the top and back of his cranium. He continued by opening up the boy's head. With the lifeless corpse on its belly, Clemente began to remove the boy's brain, scooping it out and smashing it on his back till it was mush, leaving it there and even putting some in the boy's back pockets. He then filled the empty cranium with random debris he found near the bank: mud, sticks and small rocks.

Still, not completely done, he closed the boy's head and turned the body over. Straddling the corpse, he cut off the ears, all while laughing maniacally. He decided that his revenge was not yet complete, however. He wanted to take a souvenir with him. So Clemente, with his bare hands, went to the boy's head, burrowed his thumbs deep into the eye socket and gouged out one of the eyes, which he stuck in his vest's breast pocket. This final act left Clemente completely satisfied.

While the murder was taking place, Kirby (the younger brother) was off to find help. Running from the attack, he went to a nearby road and stopped the first people he found, two old men driving their buggy. Kirby came out screaming, "A Mexican is down in the brush after my brother with rocks!" and "I want you to go down there and make him stop!" A.G. and L.P. Holmes, also brothers, were quickly led to the scene. One later testified, "He was mutilated as bad as anything I ever saw in the world. I never seen anything like it. I don't want to see any more like it. His skull was broke all behind, plumb open on both sides." There, still at the scene, was Apolinar, all covered in blood. He stood up, pulling back the bloody rock, and yelled for those men to leave. So they did.

While the Holmes brothers were down by the creek, Kirby was off searching for more reinforcements. Clemente was way too much for any two men to handle alone. He stopped a brick delivery truck in which an African American, Elijah Johnson, was driving. By this time, Kirby knew that his brother was already dead, so he shouted out to Johnson, "Oh, will you please stop. A Mexican has killed my brother!" Johnson jumped out of the truck, grabbing his sitting board—a piece of one-by-six-foot wood—and rushed down to the water. Kirby warned, "He'll kill you!"

Johnson shouted back, "Oh, I'm not afraid of him." At that time, Clemente was about to take off. Johnson came to the murder scene and saw him whistling and singing in the most lunatic way. By this behavior, Johnson was convinced he should go get his shotgun. By the time he returned, Clemente had vanished from the scene.

After leaving the scene of his gory deed, Clemente came to familiar homes and faces in the street. Bragging about killing the little white boy and still covered in blood with the same bloody rock he crushed the boy's head with in hand, Clemente went up to people showing off his souvenir. Pulling out the boy's eye from his vest pocket and holding it in his other hand, he forced people to stare at it. He bragged about the murder of the boy and said disgusting phrases referring to the eye: "Don't it look like the eye of a dog?" or "Don't it look like a little marble?" From person to person, he went through the area; he was very proud of what he had done.

Soon after, the police caught up with him; he was easily found, being covered in blood and raging. He told the arresting officer, "I'm crazy. The law can't touch me." They threw him into the old Bexar County jail, where he was to await his trial.

Indeed, Clemente was crazy, and all who met him instantly knew that. Early in life, he was seen as different. Developing slower than children of his own age, he identified himself with children years younger than he was. Often picked on, he fought with other children. Once, he was caught in a rock fight and took a violent blow to the head. Never treated, physicians believed his brain's temporal lobe was damaged. Unknown in those days, the symptoms he had would have included seizures, violent rages, paranoia, lack of facial expression, schizophrenia and hallucinations. He was never the same after that. Throughout his life, he was committed to the South Western Insane Asylum located in Southeast San Antonio three times being found insane: 1907, 1909 and 1916. Whenever committed, he would always find a way to escape and often got into more trouble.

The trial began, and of course, he was found guilty. He never denied what he had done but, in fact, bragged about killing the little

boy. The murder of young Theodore is considered to this day San Antonio's most brutal murder.

At this time what would be done with Clemente was unknown. Most heard the sorrowful cries of a mother, "Won't they do something to that man who took my boy from me?" Sides were taken, and the city became divided. One half of the city, the Mexican American population, wanted life for the insane and misunderstood man, while the other half of the city wanted Clemente, a symbol of evil, to be put to death for the brutal crime he committed. It was up in the air for the court to decide his mental consciousness and his fate.

Testimonies where made during a nine-day insanity hearing. Thousands of people swarmed the courthouse to hear what would be done, some to give support to Clemente. During the hearings, Clemente's character was on the line. One physician declared that Clemente had a "mania to kill." Most believed he would kill again. His brother and mother said a few words, stating he was not sane; he was haunted by ghosts and suffered hallucinations. But what caught the jury was the damning statement by Clemente as he explained that "I would have killed the other boy too if he wouldn't have gotten away!"

Maybe no one knew what to do with him other than put Clemente out of his misery. But the all-white male jury found Clemente legally sane. They believed he knew and could distinguish the differences between right and wrong and should pay the price. The sentencing came immediately afterward. Clemente Apolinar would suffer the consequences of his actions and would hang until he was dead.

Many praised the judicial systems of Bexar County because justice would be served. But for many, the judicial system had failed Clemente. Those who believed that did not want the death penalty for Clemente but wanted him institutionalized for life. Petitions for a retrial made their ways to the governor of the state. Riots even took place in the streets, but still, nothing could change Clemente's fate.

Almost two years went by, and finally, in 1923, Clemente sat in his jail cell of the old Bexar County jail awaiting his execution. For him and his family, February 23 came a little too soon. On the day of his hanging, Clemente was refused his final rites by the Catholic Church;

he ate his final meal and said his goodbyes to his family. By 11:00 a.m., all was ready for his execution. Sheriff John W. Tobin had the family leave as he read Clemente his death warrant. Then, the prisoner was escorted to the gallows.

As he walked to the gallows, hands tied behind his back and shackles around his feet, the other prisoners sang familiar tunes to ease his heart, "Lord I'm Coming Home to Sin No More" and "Nearer My God to Thee."

On the third floor, all awaited the moment Clemente would fall through to his death. That day, crowds of people came from all over. An estimated five thousand people gathered around the jail just to hear the slam of the trap door as he fell through. Some climbed buildings and trees just to get a glimpse of the lifeless body. This was a day most waited for.

As Clemente was placed over the trap door, the executioner gave him the option all prisoners were allowed: to wear the black hood or not. On record, Clemente was the only prisoner to reject wearing it. The noose was then placed around his neck.

At 11:07 a.m., he faced the crowd and said his final words: "Adios. My Jesus, mercy; Mary, my mother, help me."

The lever was pulled, the trap door slammed open and Clemente disappeared from the third floor's view. The audience became hushed as it watched him fall through to the second level.

Most were horrified when his body came into view. Something horrible had happened that had never been seen before. The force of gravity had snapped his neck and the rope tightened, crushing the larynx—death was almost certainly instant. But what happened during that instant would be remembered forever. The rope severed the neck, almost decapitating the head from the body. The jugular vein and the carotid artery were sliced and people up to eight feet into the audience became covered in Clemente's blood. People screamed and ran for the doors. This was not supposed to happen.

News of Clemente's hanging spread like wildfire throughout the city, and people from all over South Texas could not stop talking about Clemente Apolinar and the awful fate he suffered.

Tombstone of Clemente Apolinar located in San Fernando Cemetery 1.

During his funeral service, more than eight thousand people filed by to see Apolinar's body. He was buried the Sunday after the hanging in the San Fernando Cemetery 1, where just as many came by to show their respects. There at his grave, flowers were piled waist high for weeks.

Whether you believe justice was served or not, Clemente became a legend. Known for viciously murdering that little boy and for what some believed to be an unfair trial of the mentally insane, his story will remain known forever here.

Because of what had happened to Clemente, hangings were seen as inhumane and soon were abolished. However, not much later, the electric chair was invented and introduced inside the jail as a more "humane and effective way of execution."

In 1962, due to overcrowding, the original Bexar County jail closed. The city had grown so rapidly over the near century of the jail's existence that the building was found to be obsolete, and a new jail was built. However, the building did not remain dormant. It

was bought and used as a county polling site for years until 1983, when the Bexar County jail started using the building as an archival storage facility.

Years passed by, and our once famous jail began to be overlooked and unnoticed. Thoughts, stories and memories of the old Bexar County jail began to dissipate.

In 2002, the building was restored to life. The Comfort Inn Hotel chain was looking for a new building to place a hotel close to the River Walk. It was directed to the old jail and decided its location would be perfect. Comfort Inn purchased the building for over $800,000 and soon began preparations to completely change it. However, the San Antonio Conservation Society reminded the hotel chain that this was an historic building. Therefore, the company could not change the exterior, only the interior. So the original bars and outside façade still look very much the same as they did so many years ago. Today, it is a Holiday Inn Express and attracts thousands of visitors a year. Very few of these guests know the history and events that once took place inside of this hotel.

Ghost sightings and unexplainable experiences seem to haunt the hotel today. Guests often complain about their rooms being extremely cold, even during the summer heat. Some have tried turning on the heater in an effort to warm the room, but it doesn't seem to help. Other guests are scared to come back to their rooms because their windows have been opened and lights turned on while they were away. This is strange, for the windows are very old and original to when it was a jail. There are signs posted everywhere stating not to open them because of their age.

Recently a mother and son stayed at the hotel, and they related to us an experience they had while they were there. They had come back from a long day of sightseeing and were exhausted. They went up to their room and found that everything had been cleaned while they were away—everything, that is, except for the bed. She thought it was strange that the staff had forgotten to make it. As she was looking closely, she suddenly noticed an indenture in the bed, as if a person were on it. She reached out her hand to touch the place, and suddenly,

the indenture disappeared. As if someone or something had just gotten off the bed. She also noticed that when she had touched the bed, she felt body heat, as if someone was just sleeping there. Scared by this experience, they asked to change rooms.

People who stay at the original jail have complained to the front desk in the morning about hearing whispering and voices in their rooms. When they awake and turn on the lights, the voices disappear. Some have even awoken to the sound of men singing in their ears.

The breakfast area in the lobby sometimes has to be placed back together. During the night, furniture and chairs are rearranged, flipped over and placed in odd spots. We were told by the front desk that the original noose that hanged Clemente was once hanging from the lobby wall. Some people were offended by this, and they had to take it down. Today, it hangs inside a local sheriffs' office.

One night, when a security guard was on duty in the lobby, he said a young man came running down the stairs carrying his luggage and only wearing his boxer shorts. He looked terrified, and it took him a while to speak. When he did, he said we wanted to leave the hotel. He said while he was working late on his laptop computer, it was suddenly lifted out of his hands and thrown violently against the wall. He sensed a dark presence in the room and grabbed his stuff before he took off running. He checked out of the hotel and vowed he would never come back again.

So the next time you are in San Antonio and looking for a place to stay on a budget, you know where to choose, the Holiday Inn Express, our former Bexar County jail.

BIBLIOGRAPHY

Cary, Michael. "Sleeping in the Big House." *SA Current (San Antonio)*, December 16, 2004.

"City of San Antonio Official Website: Parks & Recreation Department." http://www.sanantonio.gov/parksandrec/directory_comanche_lookout.aspx (accessed July 1, 2013).

Eckhardt, C.F. "San Antonio's Blue Book." *All about Texas*. http://www.texasescapes.com/CFEckhardt/San-Antonios-Blue-Book.htm (accessed December 2012).

Famous Texans. "Richard King." http://www.famoustexans.com/RichardKing.htm (accessed July 5, 2013).

Gaines, Ann Graham. "San Fernando Cathedral." Handbook of Texas Online. Texas State Historical Association (TSHA): A Digital Gateway to Texas History. http://www.tshaonline.org/handbook/online/articles/ivs01 (accessed April 7, 2013).

Historic Hotels of America. "San Antonio Hotels: The Menger Hotel." http://www.historichotels.org/hotels-resorts/the-menger-hotel/history.php (accessed April 24, 2011).

King Ranch. "The Legacy: Overview." http://www.king-ranch.com/legacy_overview.html (accessed July 5, 2013).

Legends of America. "Fannie Porter: San Antonio's Famous Madam." http://www.legendsofamerica.com/tx-fannieporter.html (accessed June 1, 2013).

Legends of America. "The Menger Hotel in San Antonio Texas." http://www.legendsofamerica.com/tx-mengerhotel.html (accessed December 12, 2012).

Michaels, Stephen. "Comanche Lookout Park, San Antonio, Texas." *All about Texas*. Last modified February 2008. http://www. texasescapes.com/SanAntonioTx/Comanche-Lookout-Park-San-Antonio-Texas.htm.

The Russell Rush Haunted Tour. "Comanche Look-out Hill: All Haunted Tour Investigations." http://www.therussellrushhauntedtour.com/ pages/allinvestigations.html?feed=463830&article=10463655 (accessed July 1, 2013).

Saldana, Hector. "Fiendish Killer, a Symbol of Injustice to Some, Was Sicker Than Many Realized." *San Antonio Express News*, September 20, 2003: 1k–5k.

San Antonio Conservation Society. "Easements: Old Bexar County Jail." http://www.saconservation.org/PreservationPrograms/Easements/ tabid/138/ArticleID/24/ArtMID/515/Old-Bexar-County-Jail.aspx (accessed June 15, 2013).

San Antonio Hotels. "Haunted Hotels San Antonio: Emily Morgan Haunted Hotel." http://www.emilymorganhotel.com/haunted-hotel (accessed March 1, 2013).

San Fernando Cathedral. http://www.sfcathedral.org (accessed April 7, 2013).

Schilz, Jodye Lynn Dickon. "Council House Fight." Handbook of Texas Online. Texas State Historical Association (TSHA): A Digital Gateway to Texas History. http://www.tshaonline.org/handbook/ online/articles/btc01 (accessed May 16, 2013).

Towery, Bill. "Last Words: 'Jesus, Mary Help Me.'" *San Antonio Light*, November 14, 1976: 2A–3A.

2020GarysPlace. "West Side of the Creek." http://2020garysplace. com/-West_Side_of_the_Creek_.html (accessed June 10, 2013).

Unknown. *The Blue Book: For visitors, Tourists and Those Seeking A Good Time While In San Antonio, Texas*. 1911–1912 ed. San Antonio, n.d.

Victoria's Black Swan Inn. "History." http://www.victoriasblackswaninn. com/history.htm (accessed December 20, 2012).

Williams, Docia Schultz. *The History and Mystery of the Menger Hotel*. Plano: Republic of Texas Press, 2000.

ABOUT THE AUTHORS

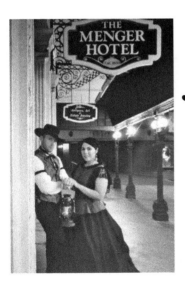

James and Lauren Swartz are a husband-and-wife duo who owns and operates Sisters Grimm Ghost Tours in San Antonio, Texas. They both have a great love for the history of San Antonio and enjoy sharing the city's spooky ghost stories. They have written this book to allow people the chance to get to know some of San Antonio's darker secrets and its most frightening tales.